DOODLING FOR DOG PEOPLE

by Gemma Correll

Quarto is the authority on a wide range of topics. Quarto educates, entertains, and enriches the lives of our readers enthusiasts and lovers of hands-on living. www.quartoknows.com

.........

© 2015 Quarto Publishing Group USA Inc. Published by Walter Foster Publishing, a division of Quarto Publishing Group USA Inc. All rights reserved. Walter Foster is a registered trademark.

> Artwork and font © 2015 Gemma Correll Illustrated and written by Gemma Correll Select text by Stephanie Carbajal

All rights reserved. No part of this book may be reproduced in any form without written permission of the copyright owners. All images in this book have been reproduced with the knowledge and prior consent of the artists concerned, and no responsibility is accepted by producer, publisher, or printer for any infringement of copyright or otherwise, arising from the contents of this publication. Every effort has been made to ensure that credits accurately comply with information supplied. We apologize for any inaccuracies that may have occurred and will resolve inaccurate or missing information in a subsequent reprinting of the book.

6 Orchard Road, Suite 100 Lake Forest, CA 92630 quartoknows.com Visit our blogs at quartoknows.com

This book has been produced to aid the aspiring artist. Reproduction of the work for study or finished art is permissible. Any art produced or photomechanically reproduced from this publication for commercial purposes is forbidden without written consent from the publisher, Walter Foster Publishing.

Printed in China

TABLE OF CONTENTS

	How to Use This Book420 Signs You're a Dog Person6Doodled Dogs10Dogs from A to Z13Doodled Dog Faces18Dog-Spressions22Anthropomorphic Dogs26Dogs in Costumes32Make a Doodled Mug40Draw a Gorgeous Greyhound46Dogs & Cats50Draw a Funny French Bulldog54Dog-Toids64Dog-Toids68Draw a Dapper Dachshund76Dozens of Dogs80Draw a Bitchin' Bichon Frise86Draw a Perky Poodle94Dogs in Hats98Funky Fur102Food!112Playtime!114A Day in the Life116Traveling Dogs118Doodle Diary124
	A Day in the Life
	Iraveling Dogs II8
1	Doodle Diary
•	About the Illustrator 128

HOW TO USE THIS BOOK

This book is just a guide. Each artist has his or her own style. Using your imagination will make the drawings more unique and special! The fun of doodling comes from not trying too hard. So don't worry about making mistakes or trying to achieve perfection.

Here are some tips to help you get the most of this doodling book.

DOODLE PROMPTS

The prompts in this book are designed to get your creative juices flowing—and your pen and pencil moving! Don't think too much about the prompts; just start drawing and see where your imagination takes you. There's no such thing as a mistake in doodling!

STEP-BY-STEP EXERCISES

Following the step-by-step exercises is fun and easy! The red lines show you the next step. The black lines are the steps you've already completed.

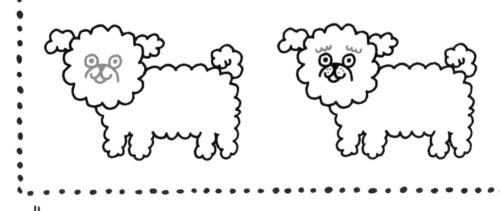

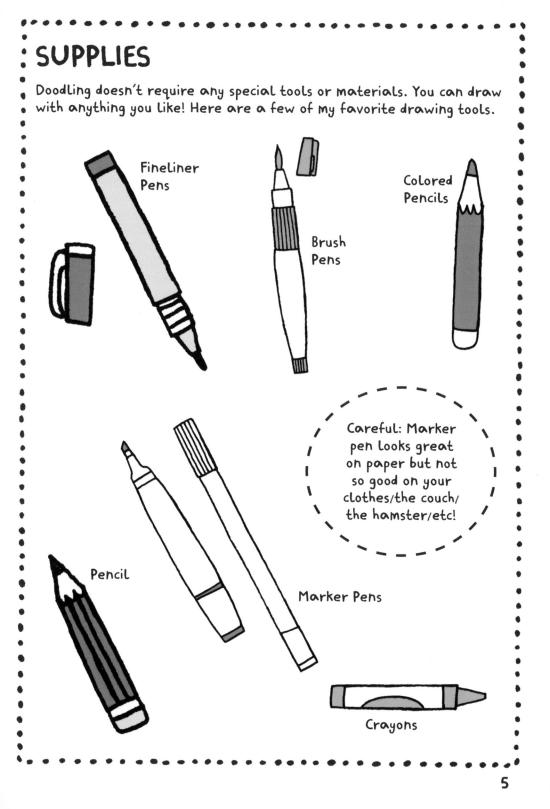

20 SIGNS YOU'RE A DOG PERSON

- I. You celebrate your dog's birthday.
- Your phone is full of photos of your dog not your friends and loved ones.
- 3. You eat budget meals, while your dog dines like a prince.
- 4. You are perpetually covered in fur and drool.
- 5. You send holiday cards signed by you and your dog.
- 6. Your cookie jar is full of doggie biscuits.
- 7. Your favorite place to shop is the pet store.
- 8. You have separation anxiety when you're away from your dog for even a few minutes.
- 9. You get jealous when your dog cuddles with somebody else.
- 10. Your pockets are full of poop pick-up bags.

- 11. You talk to your dog when nobody else is around.
- 12. Your dog's grooming costs more than your own haircut.
- 13. Your dog has his own website and Facebook page.
- 14. Your email address is dogperson@ilovedogs.com.
- 15. You learned to knit just so that you could make winter sweaters for your pooch.
- 16. Your social life (or lack thereof) revolves around your dog.
- 17. The couch and the chair are full of dogs. That's okay; you'll sit on the floor.
- 18. Your alarm clock is a wet nose to the forehead and three licks to the face.
- 19. Your doormat says, "Wipe your paws."
- 20. You haven't worn a pair of matching socks since Fido first came home.

7

MY DOG

Favorite game:

Favorite place to sleep:

Favorite toy:

Favorite snack or treat:

Favorite way to be naughty:

DOODLED DOGS

Dogs come in all shapes and sizes-From teeny-tiny chihuahuas and enormous great danes to squishy-faced pugs and skinny whippets.

SMALL DOGS

Chihuahua

Pomeranian

Yorkshire Terrier

French Bulldog

Pug

Miniature Pinscher

Dachshund

Bichon Frise

MEDIUM DOGS

English Bulldog

Beagle

Schnauzer

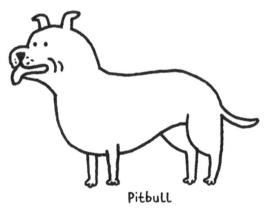

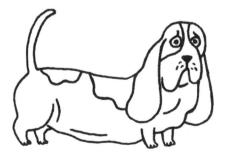

Basset Hound

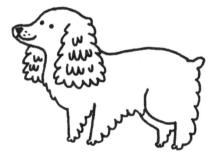

Cocker Spaniel

LARGE DOGS

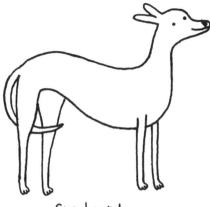

Greyhound

Standard Poodle

Rough Collie

Afghan Hound

Weimaraner

DOGS FROM A TO Z

Can you think of a dog breed for each letter of the alphabet? Some of the more challenging letters have been filled in to help you get started!

Α.	N.
Β.	0.
С.	Ρ.
D.	Q
Ε.	R.
F	S.
G.	т.
H. Harrier	U. Utonagan
l	V. Vizsla
J. Japanese Chin	W.
к.	X. Xoloitzcuintli
L	<u>Y.</u>
Μ.	Z. Zuchon

What are some of your favorite breeds? Doodle them here. . • 14

********	• • • • • • • • • • • •	• • • • • • • •	
· Doodle more d	loggy fun here!		
•			•
			•
			•
•			•
•			•
•			•
•			•
•			•
•			•
•			•
•			•
•			•
•			•
•			•
•			
•			•
•			•
•			•
•			
•			
•			
•			•
•			•
•			•
16		• • • • • • • • •	• • • • • • • •

•	•
•	•
•	•
•	•
•	•
•	•
•	•
•	•
•	•
•	•
•	
•	
•	
•	•
•	
•	٠
•	•
•	•
•	٠
•	•
•	•
	•
	•
	•
	•
	•
	•
	•
	•
•	•
	•
•	•
•	•
	•
•	•
•	•
•	
•	
•	
•	
•	•
•	
•	•
•	٠
•	•
	•
	•
	•
•••••••••	
	19
	17

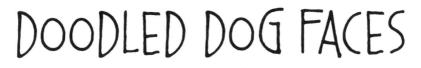

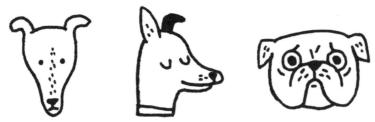

Some dogs have long noses. Some have squishy noses.

Some dogs have really big eyes. Some have small eyes.

Some dogs have sticky-up ears. Others have floppy ears.

Some dogs have wide faces. Some have thin faces.

Some dogs look worried all the time (even if they're smiling inside).

Some dogs have eyebrows that make them Look very serious.

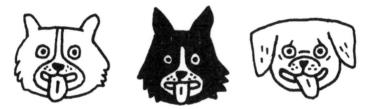

Some dogs like to stick their tongues out a lot.

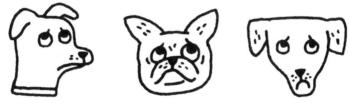

Some dogs are really good at looking pathetic so that you'll give them treats... Okay, so that's ALL dogs.

•		•
•		•
•		•
•		•
•		•
		•
		•
		•
		•
•		•
•		٠
•		•
		٠
		•
•		
•		
•		•
•		•
•		•
•		•
•		•
•		•
		٠
		•
		•
•		٠
•		•
•		
•		•
•		•
•		•
•		•
•		•
•		
•		
•		
•		
•		•
•		•
•		•
•		•
•		•
•		•
•		•
•		•
••••••••	••••••	• • • • • • • • •
		21
		21

DOG-SPRESSIONS

Dogs show their feelings with their ears and faces.

Sleepy

Cheeky

Worried

Scared

Annoyed

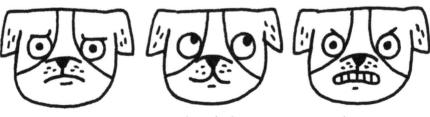

Suspicious

Thoughtful

Angry

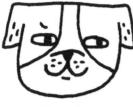

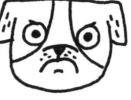

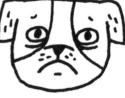

Sneaky

Grumpy

Watchful

Expectant

Impatient

Guilty

Content

Excited

Silly

Drunk?

What kinds of faces does your dog make? Doodle your loveable canine expressing a range of emotions.

ANTHROPOMORPHIC DOGS

These dogs have been anthropomorphized (that's fancy talk for "attributing human characteristics to animals"). To draw an anthropomorphic dog, just imagine you're drawing a person, but with a dog's head—and paws instead of hands!

Becca Boston Terrier Blogger

Walter Whippet the Waiter

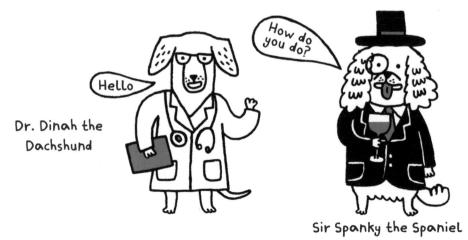

26

Lucky the Lab Technician

King Charles Spaniel III

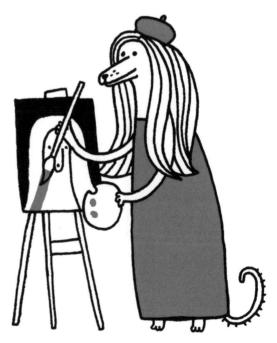

Alison Afghan the Artist

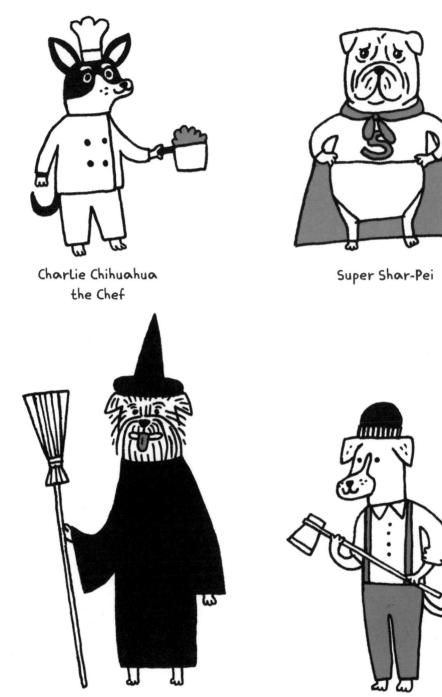

Wendy the Wolfhound Witch

Lumber Jack Russell

 If your dog had a profession (other than "Professional Cutie-Pie"), what would it be 	?
• Doodle your ideas here.	•
•	•
• • • • • • • • • • • • • • • • • • • •	• • •
• • •	6 6 6
• • • •	9 9 9 9
6 6 7 7	•
• • • •	•
•	

•	
•	•
•	•
•	
•	•
•	•
•	•
•	•
•	•
•	
•	•
•	•
•	•
•	•
•	•
•	•
	•
•	i
•	•
	•
•	
•	•
	•
•	•
•	•
	•
•	•
•	•
	•
•	•
•	•
•	•
•	•
	•
•	•
•	•
•	•
•	
	31

DOGS IN COSTUMES

What does a dog love more than sleeping, walking, and playing combined? Why, dressing up of course!

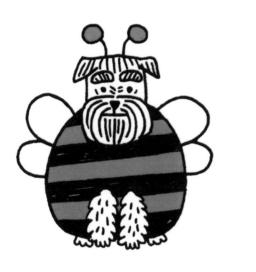

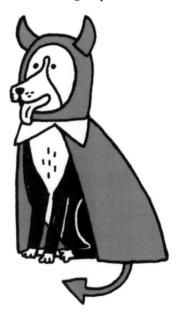

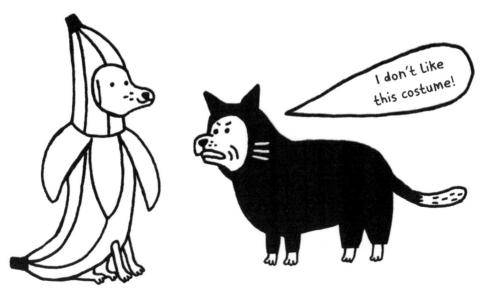

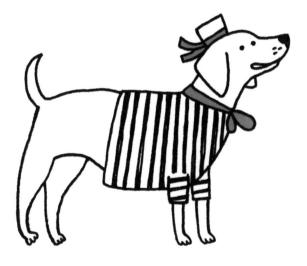

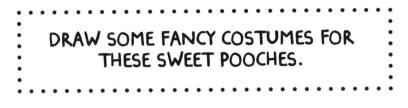

لحالحا كماكحا

5

س ليالي سه

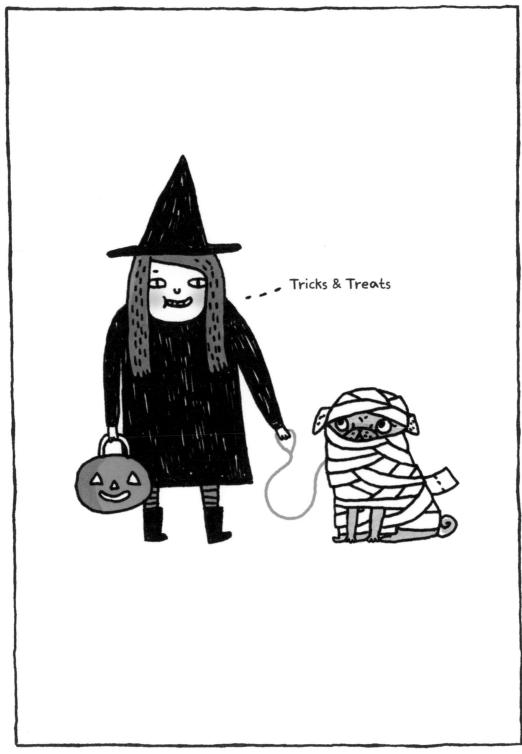

Jour deg in et lun coscume.	Draw	your	dog	in	0	fun	costume!
-----------------------------	------	------	-----	----	---	-----	----------

Note: Your dog's definition of "fun" may differ from yours...

Doodle more dogs in costumes and outfits here!	•
	•
	•
	•
))
•	8
	•
	•
• • •	•
•	•
•	•
38	•

	•••••
•	•
•	•
•	•
•	•
	•
•	
•	
	•
	٠
	•
•	•
•	•
•	•
•	•
•	
	•
	•
•	•
	•
•	•
	٠
	٠
•	•
	•
	•
•	•
•	•
	٠
	•
•	•
•	
•	•
•	•
•	•
	•
•	
•	•
*• • • • • • • • • • • • • • • • • • •	• • • • • • • • •
	39

MAKE A DOODLED MUG

Here's what you'll need:

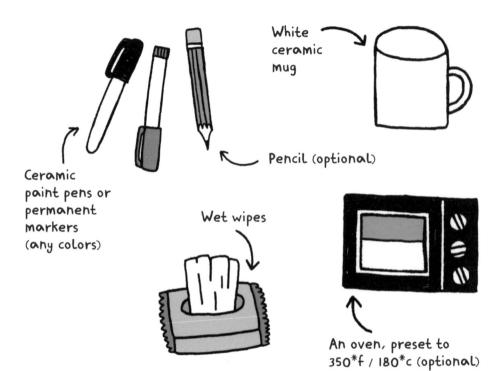

1. Decide what you're going to draw on the mug.

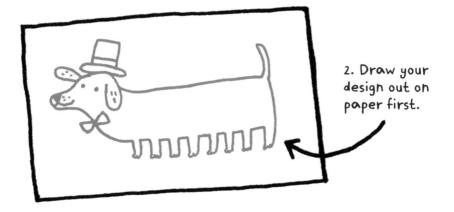

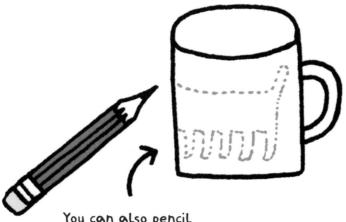

You can also pencil the design out on the mug if you feel like it.

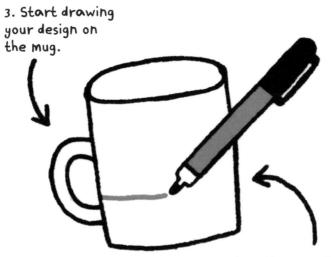

Start on the opposite side to your drawing hand so that you don't smudge your artwork as you go around the mug.

Don't worry if you make a mistake-just wipe it clean with a wet wipe while the paint is still wet. (Make sure it's dry before you continue drawing.)

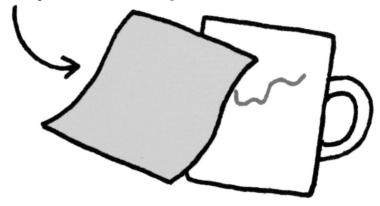

4. If you used paint pens, you can make your mug dishwasher safe by baking it in the oven for 45 minutes at 350*f / 180*c (or whatever your paint-pen packaging tells you to do).

While you wait, eat some cookies. You deserve it.

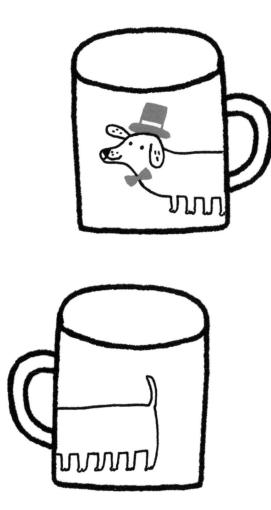

5. Ta da! Let your mug cool, and you're ready to start sipping in style.

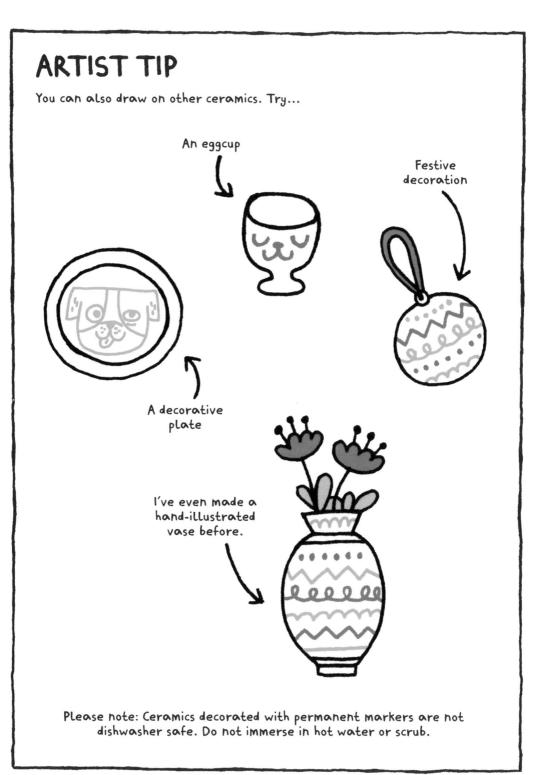

DRAW A GORGEOUS GREYHOUND

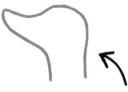

I. First draw the head shape like this.

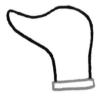

2. Add the collar.

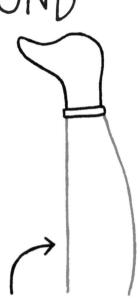

3. Draw a straight line and a curved line.

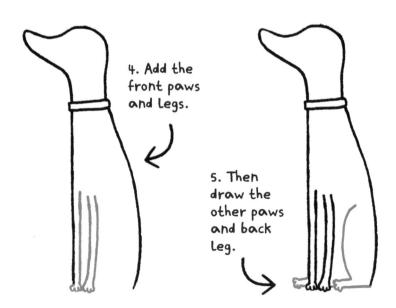

6. Draw the ears.

7. Add the tail.

8. Draw two dots for eyes, plus the nose and mouth.

9. Add any extra details you like.

•	•
•	•
•	٠
•	•
	•
	•
	•
	•
	•
•	•
•	•
•	
•	•
•	
	•
•	
•	
•	
•	•
	•
•	٠
•	•
•	•
•	
•	
•	•
•	•
	•
•	•
	•
•	•
•	•
	-
•	•
	•
	•
T	•
•	•
•	•
•	•
•	•
	•
•	•
•	
	•
	49

DOGS ON THE GO

Animate your furry friend by drawing an action in two (or more) steps. Try drawing the repeating illustrations on the corners of a stack of papers, or a small notebook. Then flip the pages, and watch the pup come to life!

Doodle here!

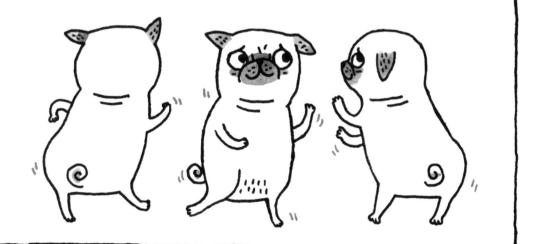

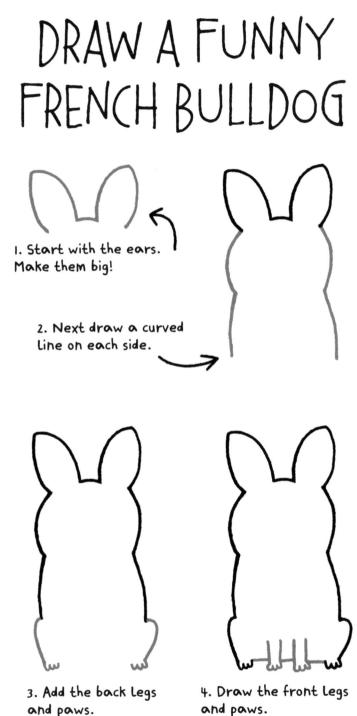

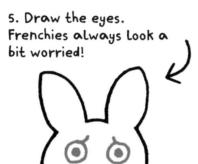

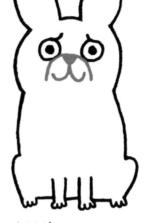

6. Add the snout, nose, and mouth directly below the eyes.

7. Finally, add the all-important wrinkles and any other details to make your Frenchie extra cute.

Finished!

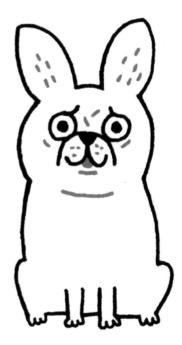

; * * * * * * * * * * * * * * * * * * *	• •
• Doodle your French bulldog here!	•
• 1	•
	•
	•
	•
	•
	•
•	•
•	•
	•
	•
•	
•	
•	•
	•
•	•
	•
•	•
•	•
	•
	•
	•
•	•
•	•
•	
•	•
•	•
• • • • • • • • • • • • • • • • • • • •	
56	

	••••••
•	•
•	•
•	•
	•
•	•
	•
•	•
•	
•	
•	•
•	٠
•	•
•	•
	•
	٠
	•
	•
	•
•	•
•	•
	٠
	٠
	•
•	•
•	•
	•
	•
•	
•	
•	•
•	٠
•	•
•	•
•	
•	•
•	•
*• • • • • • • • • • • • • • • • • • •	
	57

DOGS & CATS

Dogs and cats... lovers or haters? You decide!

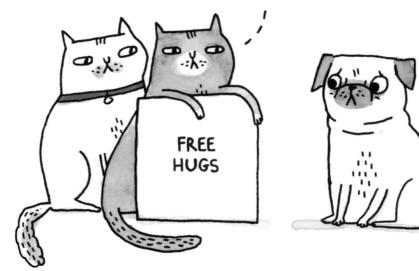

We've run out.

Ş

It will be mine. Oh yes, it will be mine.

My friend fancies you.

We met on the Internet.

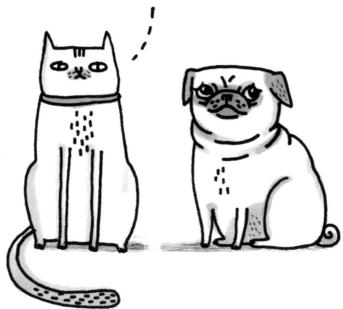

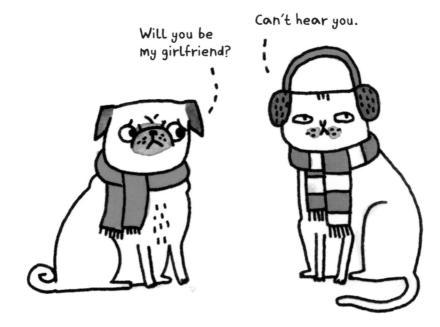

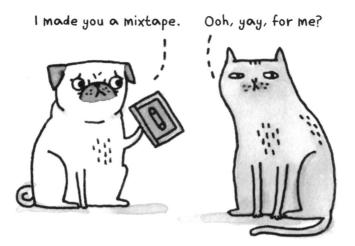

Doodle some feline counterparts with your pup. Are they friends or foes?

WHAT'S IN A NAME?

Stumped on what to name your next furry friend? Check out these suggestions for inspiration. Then add your own ideas to the list!

> Vuitton For the fashion lover

Anastrophe Perfect for the grammar geek

Mr. Darcy This one's for all you literary mavens

Monterey Jack

Admiral For the dog who rules the home

> **Basil** After your favorite herb

Target Paying homage to your favorite place to shop

> Sir Ruffington III For fancy dogs only

Newcastle Because what more do you need on a Friday night?

DOG-TOIDS

For many, dogs are a source of joy, entertainment, comfort, and Laughs. Here are just a few reasons our canine cohorts are so special!

Fact: There are more than a dozen separate muscles that control Fido's ear movements. No wonder they're so expressive!

Fact: Dogs are capable of hearing sounds at about four times the distance that humans can hear.

Fact: The "smell" center of your pup's brain is 40 times Larger than yours.

Fact: Your doggie's nose has a unique ridged pattern—like a human fingerprint!

Fact: Dogs have similar sleep patterns and brain activities as humans—next time you see your pooch twitching in her sleep, it probably means she's dreaming. **Fact:** Dogs only have sweat glands in their paws the main way they cool down is by panting.

Fact: An average dog can run about 19 miles per hour at full speed.

Fact: A wagging tail doesn't always mean a happy dog. Studies show that dogs wag their tails to the right when they are happy and to the left when they are sad.

Fact: Puppies sleep for 90 percent of the day in their first few weeks of life!

Fact: The average body temperature for a dog is a warm 101.2 degrees Fahrenheit.

Fact: Puppies have 28 teeth, and adult dogs have 42!

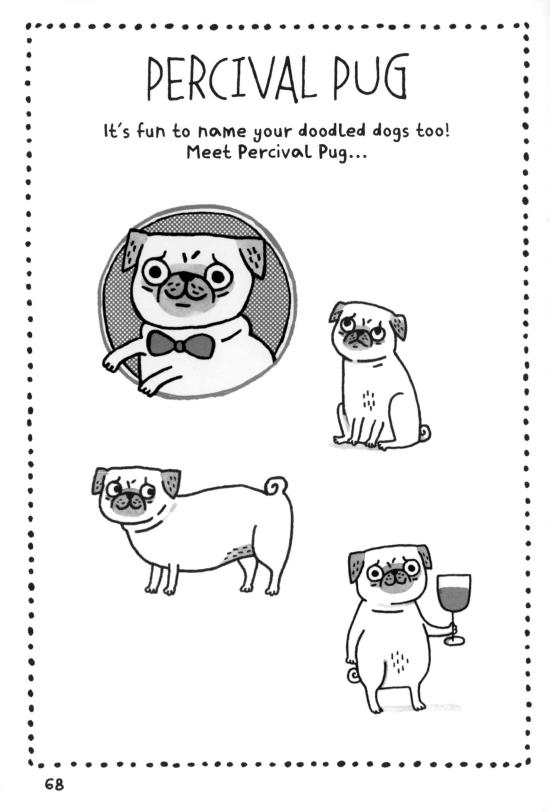

•	
•	
•	
•	
•	
•	
•	•
•	٠
•	•
•	٠
•	•
•	•
•	
•	•
•	•
•	•
•	•
•	•
	•
	٠
	•
	•
•	٠
•	•
•	•
•	•
•	•
	•
	•
•	•
•	•
•	٠
	•
•	•
•	
	•
	•
•	•
	•
•	•
** * * * * * * * * * * * * * * * * * * *	
	71
	/1

DOGGIE DIGS

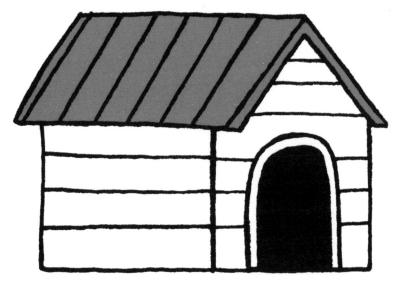

Traditional

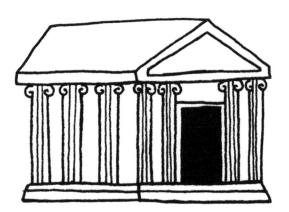

Classical

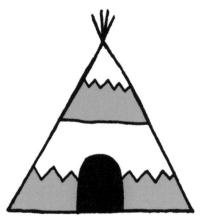

Teepee

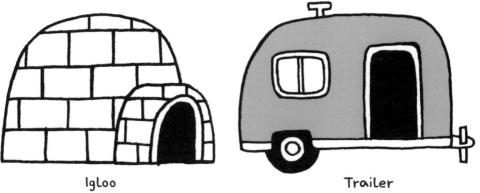

اولە

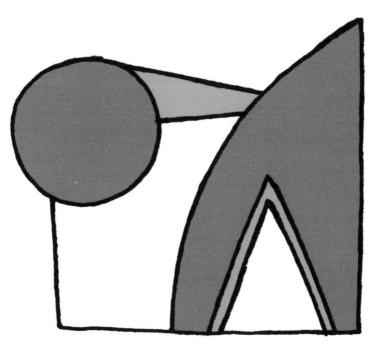

Post-Modern

• What would your dog's perfect home look like? • Doodle some ideas here.
•
• • • • • • • • • • • • • • • • • • •
•
74

DRAW A DAPPER DACHSHUND

1. Draw this shape for the head.

2. Add the ear.

3. Draw two straight, parallel lines-you can extend these to make your dachshund extra long.

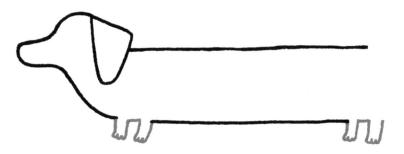

4. Next add the short legs and paws.

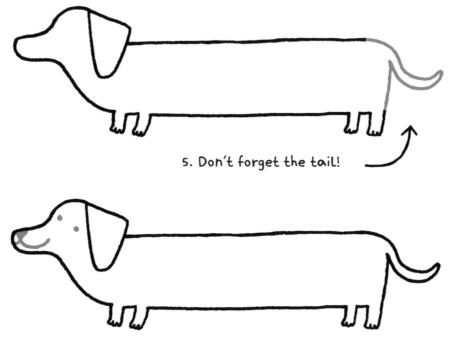

6. Draw two dots for eyes, and add the nose and mouth.

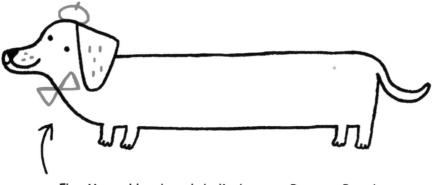

7. Finally, add extra details to your Dapper Doxy!

•	•
•	•
•	•
	•
	•
•	
•	•
•	•
•	•
•	•
•	•
•	
•	
•	•
•	
•	•
•	•
•	•
•	•
•	•
	•
	•
•	•
•	•
•	•
•	•
	•
	•
	•
	•
•	•
	•
	•
	•
•	•
	•
•	•
•	•
•	•
•	•
•	•
•	•
•	•
•	•
•	•
•	•
•	•
•	•
•	•
	•••••
	79
	/1

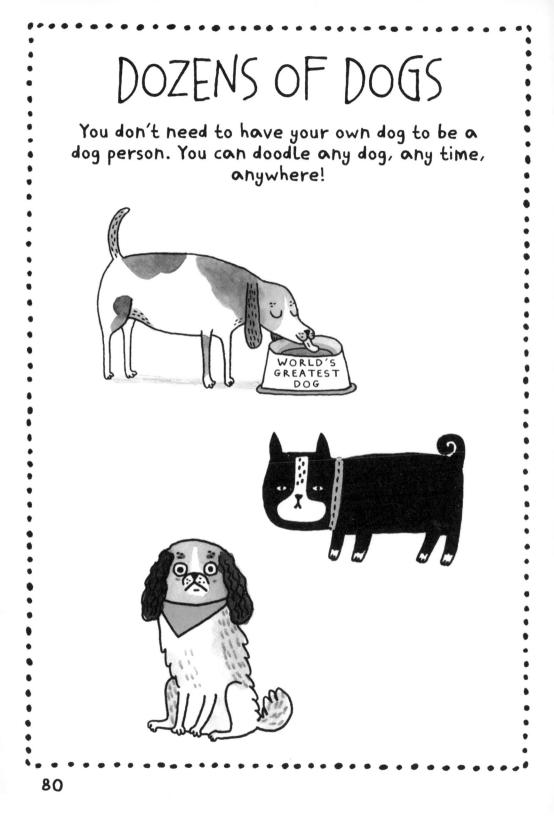

•			•
•			•
•			•
•			•
•			•
•			•
•			•
•			•
•			•
•			
•			
•			
•			
•			
•			•
•			•
•			•
•			
•			•
•			•
•			•
•			•
•			•
•			•
			•
			•
•			•
•			
•			
•			•
•			•
•			•
٠			•
•			•
•			٠
•			•
•			•
٠			•
•			•
•			•
•			•
•			•
•			•
•			•
•			•
			•
•			•
			•
•			•
0.0	 	 	
84			

DRAW A BITCHIN' BICHON FRISE

I. Draw a bubble for the head.

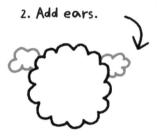

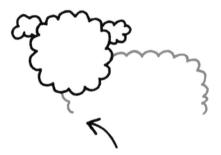

3. Draw the body, using the same bubbly line.

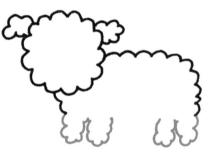

4. Next draw four legs.

5. Join the Legs together.

6. Add a bubbly, curly tail!

7. Add the face, just like the one you drew for the French bulldog on pages 54 and 55.

8. Give your bichon some eyebrows!

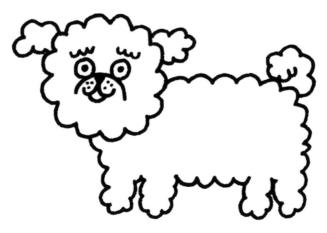

9. Finished! What a cutie!

	• • • • •
	•
•	٠
•	•
•	٠
	•
	•
	•
	•
•	
•	
•	•
	•
•	•
•	
	•
•	•
•	
•	
•	•
•	٠
	•
	٠
	٠
•	•
•	•
	•
	•
	•
	٠
	•
	٠
•	•
•	
•	•
•	•
•	٠
•	•
	•
•	•
· · · · · · · · · · · · · · · · · · ·	
	00
	89

DRAW A (OOL (OLLIE

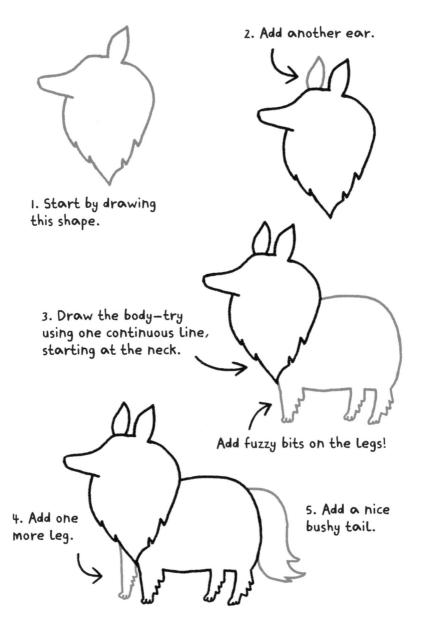

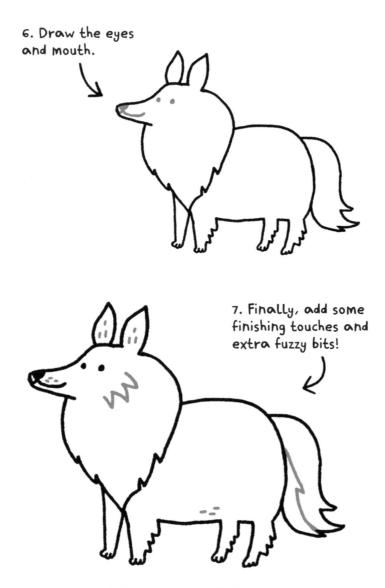

What a cool collie!

	• 1
•	•
Doodle your collie here!	
•	
• •	
•	
•	
•	
•	•
•	
	٠
	٠
	•
•	
•	
•	٠
•	٠
	٠
	٠
•	٠
•	
•	
•	•
•	
•	
•	
•	
•	٠
•	•
•	
•	•
••••••••••••••••••••••••••	
92	

•	•
•	
•	•
•	•
•	•
•	
•	•
•	•
•	
•	
•	•
•	
	•
•	٠
•	
•	•
	•
•	•
•	•
•	•
•	
•	٠
•	٠
•	•
•	
•	•
•	•
•	•
•	
•	•
•	•
•	•
•	•
•	٠
•	•
•	•
•	•
•	•
•	
	93

DRAW A PERKY POODLE 1. Start by drawing a fluffy blob! 2. Add this ..and shape for an ear. the head. 3. More fLuff! 5. Then draw the rest of the body. 4. Draw the two front legs. and don't forget the tail! 6. Now it's time to add more fluffy bits! Draw the ankles and paws like this.

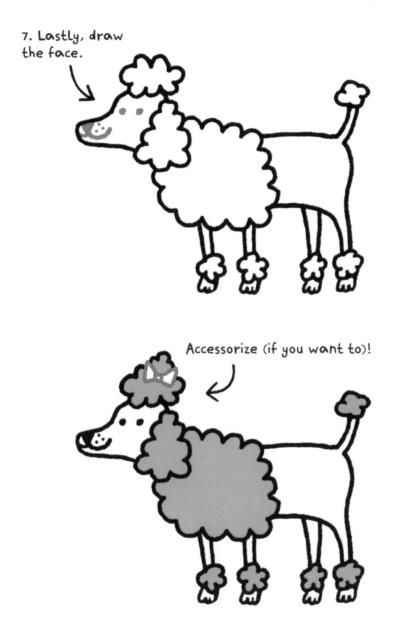

...and there you have it. One perky poodle!

DOGS IN HATS

Fez

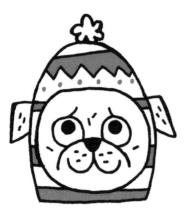

Woolly Hat

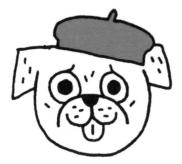

Beret

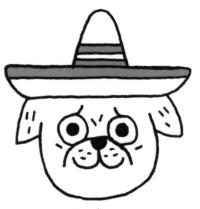

Sombrero

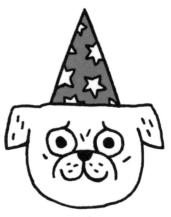

Wizard's Hat

Baseball Cap

Doodle hats on these cute pups.

Turban

Graduation Cap

Fedora

Chef's Hat

Doodle your favorite doggie sporting the latest in fashionable headwear.
•
•
•
•
•
•
•
•
•
•
•
•
•
•
•
•
•
•
•
•
•
٠ ٠ • • • • • • • • • • • • • • • • • •
100

•	•
	•
•	
1	•
•	•
	•
	•
•	•
•	
•	•
	•
•	•
•	•
•	•
•	•
•	
	•
	•
•	
•	•
	•
	•
•	
	•
•	•
•	•
•	•
	•
•	
•	•
	•
	•
	•
•	•
•	•
•	•
	•
•	•
•	
•	•
••••••••••••	
	101

FUNKYFUR

This dalmatian is at the pawfront of fashion...check out his crazy fur-styles!

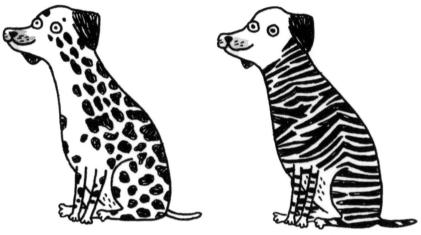

Classic Look

Zebra

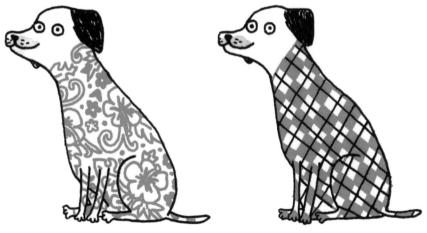

Hawaiian

Argyle

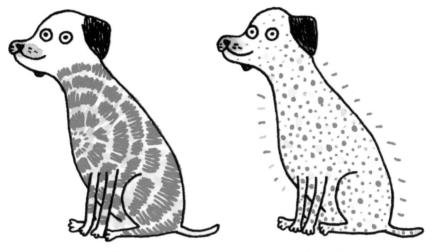

Tie-dye

Glitter!

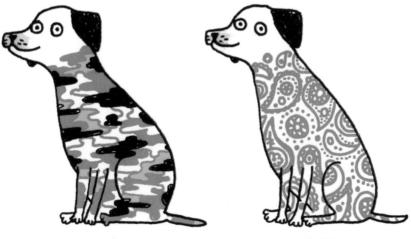

Camo

Paisley

Now it's your turn! Doodle some fabulously furtastic designs on these plain pooches. Then doodle in some doggy accessories—bones, food, balls, etc.

What other patterns can you think of? Doodle more fabulous fur-styles here.

FOOD! a.k.a. every dog's favorite thing

Fantasy Flavors

Your dog's favorite

Delicious Treats

Milk-bones

Chew sticks

The cat's treats

What does your furry friend like to snack on?

N

PLAYTIME!

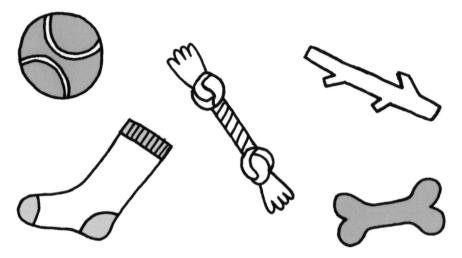

Doodle your doggie's / favorite toys.

These dogs are having fun playing in the park. Draw your dog playing too!

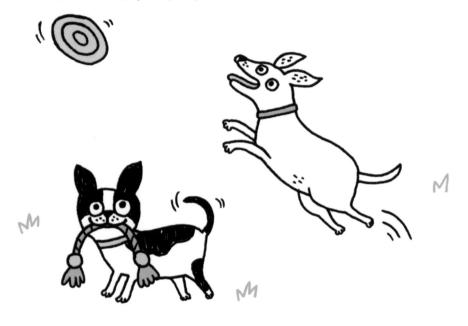

M

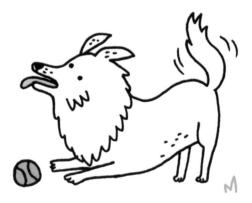

M

A DAY IN THE LIFE

Eating, sleeping, playing...not a care in the world! Our spoiled pups are truly livin' the life.

- 7:30 AM Lick Human's face repeatedly until Human gets out of bed
- 7:45 AM Once human is up, snuggle into their warm spot on the bed
- 8 AM Dog food—scatter a few pieces on the floor to save for later
- 10 AM Take Human on a walk pee on every tree

- 11 AM Naptime
- 12 PM Terrorize the cat
- IPM Potty break—bark at all the squirrels

- 3 PM Investigate the kitchen trash
- 4 PM Naptime
- 5 PM Play ball!

- 6 PM Dinner and a belly rub
- 8 PM Milk-bone treat
- 9 PM Patrol the grounds on night watch
- 10 PM Bedtime—feign sleep on dog bed
- 10:30 PM Jump into Human's bed when the snoring starts—nighty-night!

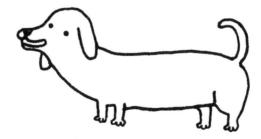

TRAVELING DOGS

These pooches are all ready to go on their travels. Where do they think they are going?

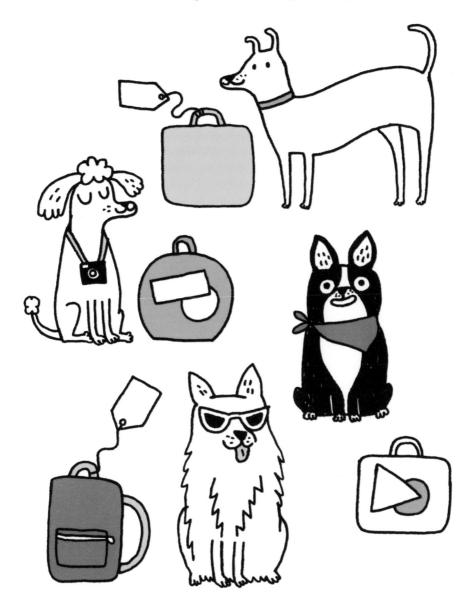

Who else is having fun at the theme park?

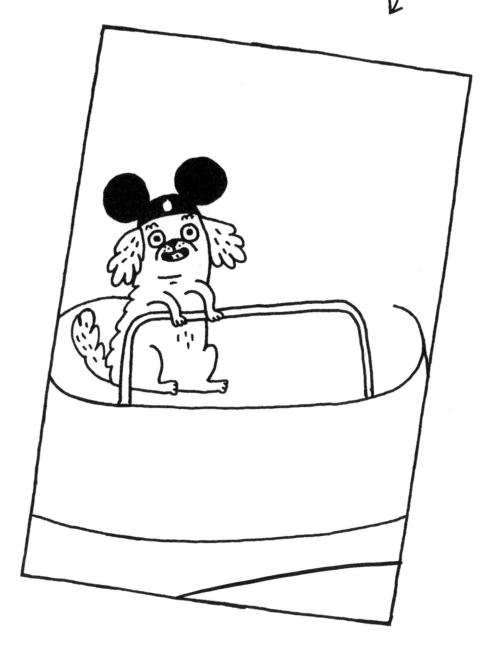

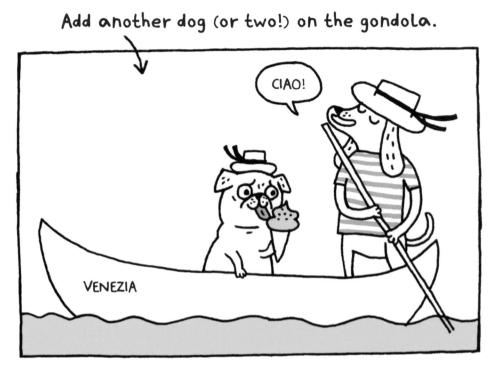

Draw another dog on a sled.

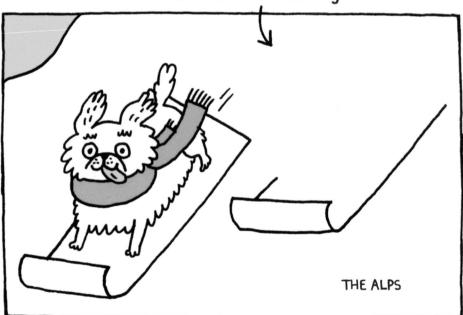

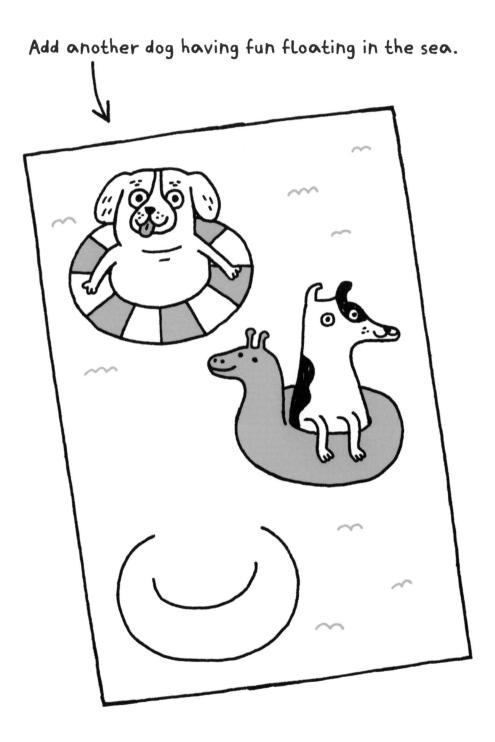

If you went on vacation with your dog, where would you go? What would you do? Doodle your plans here. Design a postcard from your amazing vacation together!

DOODLE DIARY

Use these pages to doodle all your favorite pooches — real or imaginary — doing all their favorite things.

ABOUT THE ILLUSTRATOR

Gemma Correll is a cartoonist, writer, illustrator, and all-around small person. She is the author of *A Cat's Life, A Pug's Guide to Etiquette,* and *It's a Punderful Life,* among others. Her illustration clients include Hallmark, *The New York Times,* Oxford University

Press, Knock Knock, Chronicle Books, and *The Observer*. Visit www.gemmacorrell.com to see more of Gemma's work.